House

— of —

Wonders

*To Shirley & Phil
with all good wishes
John Lindley*

John Lindley

First published 2008 by Riverdane

ISBN 978-0-9559251-0-8

Copyright © John Lindley 2008

Back cover photograph: Jane Harland

Photograph on pages 26, Peak Cavern photograph on page 37 and the
Headstone photograph on page 39: John Lindley

Photograph on page 27 used by permission of Brenda Simpson

Photographs on page 20, 34 and the photograph of Randolph and
Hettie Douglas on page 37 courtesy of Castleton Historical Society

All other photographs courtesy of Derbyshire County Council:
Buxton Museum and Art Gallery (Douglas Collection)

Design and Print: About Turn Creative

In memory of my Mother

Acknowledgements

A number of people helped in making this book a reality, some with my research into Randolph Douglas and others with advice, support and proofreading.

I would like to thank Jo Bell, Castleton Historical Society, Mark Davenport, Janet Fielding, Hannah Fox, Peter Harrison, John Higgins and Sylvia Pybus.

In particular I would like to thank Ann Beedham for generously sharing her own research findings and material on Randolph Douglas; Ros Westwood and Martha Lawrence at Buxton Museum who assisted me in so many ways with regard to my access to archive material and photographs and, finally, Jane Harland for her support throughout the whole enterprise.

Other books by John Lindley

Cheshire Rising (Cheshire County Council, 2005)
Scarecrow Crimes (New Hope International, 2002)
Stills From November Campaigns (Tarantula, 1998)
Cages and Fields (1982)
Pacific Envelope (1976)

Contents

Introduction

I wonder what constitutes wonder these days; what in this seen-it-all-before society endures to capture the imagination and spark our interest? One morning in late May 2005 I drove over to Buxton with my partner, Jane, ostensibly to check out potential gallery space in the museum there for a combined exhibition of poems and sculpture that she was involved in. Buxton, a short jaunt across the border of Cheshire into Derbyshire, was a fairly regular excursion for us, generally to explore the park, browse the book fair, visit the theatre or simply to partake in that pleasurable activity known to us all as 'pottering about'. Inexplicably, the museum had never previously figured on our agenda.

On this occasion one of the museum's galleries was displaying a collection which formed part of a celebration identified in their programme as *Objects of Desire*. We entered a world of staggering diversity; one of masks, skulls, South African hide shields, glass flutes, seed pods, Tibetan tea churns and swords made from the upper jaw bones of fish. A lead miner's straw blasting case jostled for space with a Buddhist prayer wheel, fragments of Blue John stone from nearby Castleton were neighbours to ornamental combs from the Solomon Islands. And there was more: a miniature letter ("written without the aid of a magnifying glass") and a tiny Nativity scene carved from mother of pearl, a cabinet enclosing a bafflingly intricate array of locks, a chipped and peeling wooden sign beckoning entry to *A House of Wonders*. Amongst it all was a photograph of a young man standing unconcerned, his neck and wrists shackled by a device of frighteningly excessive proportions.

That man was Randolph Douglas. All of the gallery's objects were amassed by him, the miniatures on display made by him. I'm not sure now whether my open mouth closed once in the entire time I spent navigating that exhibition. I *do* know that I was compelled to return the following day to wander again through that remarkable collection. In doing so I became increasingly intrigued by the man responsible for all this; a man who, though not himself well travelled, had collected these worldwide curiosities, acquiring them either locally or through friends and connections; a man too who had originally displayed this collection in his own cottage, charging sixpence admission for a guided tour by himself or his wife, Hetty, a tour often conducted by torchlight in the absence of electric light.

There was, too, the evidence and emerging details of Randolph Douglas's superb skill as a miniaturist and, yet more intriguing, there were those endearingly strange photographs of a youth garnished with chains and grandly referring to himself as *Randin* (later *Randini*) *the Self Liberator*.

Who was this man? Why was he not hitherto known to me? Curiosity led me swiftly into the role of amateur sleuth and what soon became apparent was that most published accounts of Randolph Douglas (and they were few) contained historical detail incorrect in even the most fundamental aspects. The most glaring of these, a publishing error committed once and seemingly repeated unquestioned thereafter, was the claim that he died "in the early 1970s", a statistic wide of its mark by almost 20 years. Other claims, particularly that of his warm acquaintanceship with the most famous escapologist and illusionist of all, Harry Houdini, seemed similarly preposterous.

Not so, as it transpired. The deep admiration that Randolph held for Houdini was clearly evident, both from his studiously compiled scrapbooks on the great man to the (almost certain) intention of homage in adding the *i* to the end of his own stage name *Randin*. The idea that they had met was not implausible, indeed recorded dates of Houdini's tours of England, particularly that of his appearance at the Empire Palace Theatre, Sheffield in April 1913, placed Randolph's attendance at the show as not only possible but, given the young fan's enthusiasm, extremely likely. An unconfirmed report even refers to Randolph attending a Houdini performance as early as 1904 and this was given possible credence when further research revealed to me that Houdini did indeed play Sheffield's Empire Theatre in January that year.

Was the eight year old Randolph Douglas taken to see the world's most famous illusionist and escape artist and was the experience to provide the catalyst for both his own early ambitions in escapology and his enduring fascination with locks? What is indisputable is that by 1913 the two men were corresponding. Those existing letters and cards reveal evidence not of a relationship between gushing admirer and obliging superstar, but one borne out of the unmistakable respect each man held for the other's remarkable skills. Thankfully, there remains a photograph of the two men pictured together.

My desire to find out about Randolph Douglas was always, at least in part, governed by a compulsion to write about him, to try and articulate, through a short series of poems, something of what intrigued me about the man and his work. I made phone calls to libraries and societies, was given generous access to Buxton Museum's archive material, read whatever I could otherwise find and visited Castleton to see the caves he loved and the cottage he'd lived in. I explored and delighted in the museum housed in the Tourist Information Centre, with its small yet wonderful display of his work.

Few I spoke to in Castleton remembered much of him and Randolph emerged (contrary to the showman-like nature of his hobbies) as a quiet and unassuming figure, witnessed each working day carrying a small bag on his way to Hadfield's Steelworks in Sheffield. Nevertheless, some colourful anecdotes did emerge: his devoted wife, Hetty, unselfconsciously dressed in revealing knitwear as she took admission at the entrance to their cottage museum; Randolph being summoned, on more than one occasion, to use his astonishing knowledge of locks to 'break into' the local bank whenever some luckless employee misplaced the key.

In truth, however, I learned very little of Randolph Douglas; about his life, his work, his compulsions and reasons. And, at least as far as the poems went, that was fine by me. I was not, after all, attempting to write his biography. Occasionally when I write poetry that has its roots in historical fact, I am happy for those facts to be sketchy. I want the resultant poems – rarely more so than in this case – to be more than simply a litany of dates and events. In short, I want the poems to leave space for the freedom to wonder.

I wonder what constitutes wonder these days? I wonder, for instance, whether Randolph Douglas - this otherwise apparently ordinary, happily married, conscientious and level-headed man - was, at heart, something of an oddball, an eccentric, a crank? I hope so. Today, more than ever, I believe we need such people.

John Lindley

Step Inside

Enter here.
It's 1926,
eight years out of Hell
and the men still coming home.

Elsewhere
there's magic in the air:
a Scotsman sets pictures
shivering on glass,
words stutter through wires
from London to New York
and in Treak Cliff
they've broken open
Aladdin's Cave.

But enter here –
Eastertide,
the year six months shy
of Houdini's death.

Follow this light.
There are weapons and butterflies
at the furred edge of its beam,
a treasure chest from Spain
in the centre of its white eye.

Those are cedar cones
from the Lebanon that you can smell.
This is a house of wonders.
Be amazed.
Turn left at the next page.

Bold As Brass

New Year's Eve 1899

On the hinge of the century
at four years old
he knows nothing
yet all of this.

He has been smelted
from metal stock,
hand-hammered by genetics
into the trappings of trade

but it's not a hard heart:
it is one bold as brass,
one buffed and burnished
until it shines.

And when this liquid silver boy solidifies
it will be as more than mechanic,
more than engineer
and more than DNA's dull design.

Already, under the quicksilver pelt
of a spent century's sky,
Randolph is unknowingly
sandblasting his destiny.

With the encyclopaedic ignorance of a child
his ears anticipate bells and ocarinas,
unmade waterwheels roll in his eyes,
uncollected labradorite lights up his head.

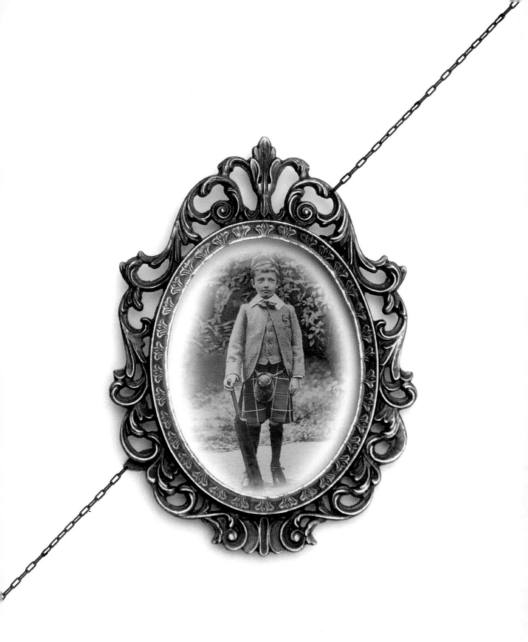

Postcards From Home

Here he is,
a fly in a web of his own weaving,
braceleted from dipped neck
to mirror-polished boots,
stooping into his chains
under eyes of dark purpose,
links dripping like charms
by his elbows and ears.

And here
as age spots fleck the image,
defiant as youth,
fists clenched,
weight on one foot,
quietly restraining himself.

And here
becoming his own miniature,
sausaged into a suitcase,
all but losing his torso and legs
in the dark, dark silk,
the tilt of a boyish face,
a rolled up sleeve,
an angled arm handcuffed
to nothing but freedom.

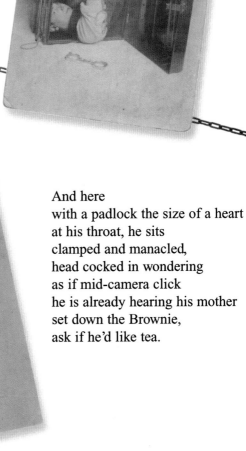

And here
with a padlock the size of a heart
at his throat, he sits
clamped and manacled,
head cocked in wondering
as if mid-camera click
he is already hearing his mother
set down the Brownie,
ask if he'd like tea.

Before Your Very Eyes

a chain is slipped, a lid is prised,
a tank of water is capsized,
a knot is loosed, a rope unties,
a ghost of coils is exorcised
before your very eyes.

Behind your very eyes
where logic, math and reason lies
and common sense says 'rationalise'
prepare to be quite mesmerised
behind your very eyes.

Before your very eyes
where magic must be recognised,
beyond your means to analyse
a card will turn, a casket rise,
a truth will dawn, you'll realise

that to your very great surprise
a teenage boy is unbaptised
and out of Randolph's thin disguise
a rebirth will be realised.
Randini will materialise

before your very eyes.

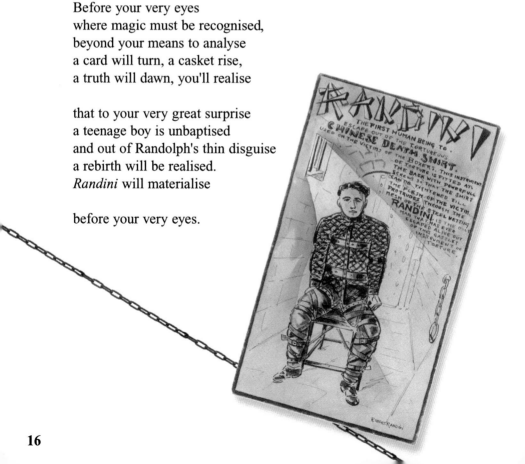

The Self Liberator

Randini engineers his escapes
the way Randolph engineers his locks –
with flair and precision.

Onstage
he is a mechanism of mind and muscle,
tuned to perfection, cute as a cog,
with the unpicking patience of a seamstress.

He poses, striped with rope and with chain,
flexes a travelling muscle from buttock to heel,
raises the only eyebrow that's free
and, with a shrug, is a snake unsheathed,
a phoenix risen, coils of restraints
pyramiding up from his feet.

He steps out and stands, hair in place,
How about that? arms outstretched.
Applause ripples around the hall
like muscles exposed,
swells like a chest thrown out.

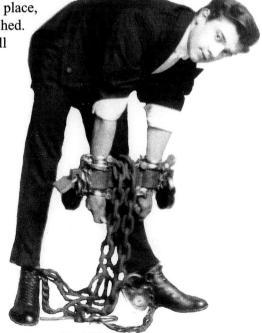

RANDINI THE SELF LIBARATER.

Rubbing Shoulders

Tight-trussed and tricked out in a straitjacket,
Houdini hangs in homage to Randolph
as Randolph had already hung, still as
a stalactite, from his bedroom ceiling.
They talk locks, swap tricks and exchange postcards –
Houdini in New York, Prague, Nuremberg,
Randolph, always Sheffield, Sheffield, Sheffield –
one sending clippings, the other pasting.
On a cold undated day, the two pose
together: half-smiles, hats and overcoats.
Rubbing shoulders, only their buttons match,
both destinies as different as their heights,
the shorter man growing large as legend,
the taller, shrinking smaller than footnotes.

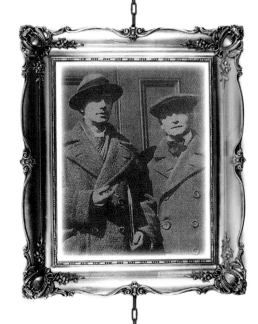

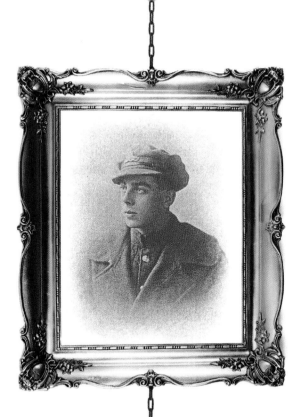

Horses In Midstream

And when he's worn the khaki,
done his bit,
left something of himself behind
as they all did
who came back from it,

he takes inventory,
subtracts war-weary muscles
from the body's ledger,
recognises the close
of one show,
the opening of another.

In The Making

His father made him these hands,
put the magnifying glass in his eye,
touched off the taper that fired his heart

but the rest is all his own work:
the world scaled down to a fingertip
or taken in through the door.

He has made a place for himself,
one of hearth and home and Hetty,
a house of wonders.

He has made a place for us:
a sixpenny slice of different
in a lifetime's worth of same.

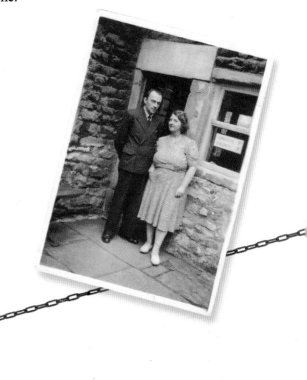

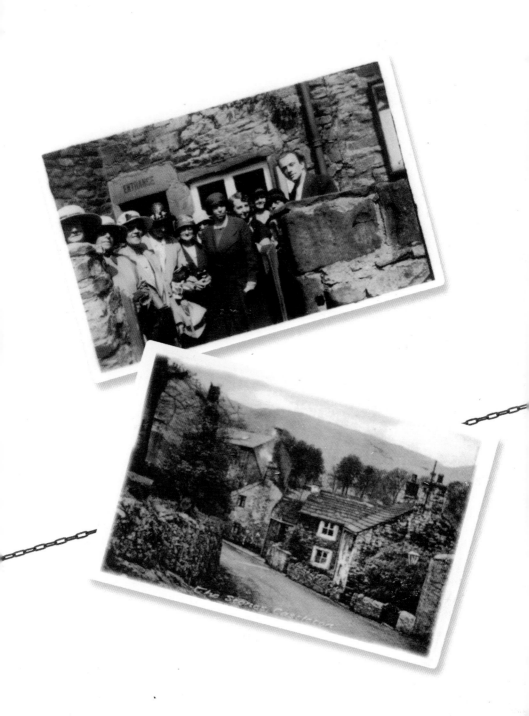

The Death Of Houdini

As an aid to immortality
a violent end takes some beating
but this one's too crude and juvenile,
too lacking in style.
Houdini should have had a death befitting his life;
should have dissolved invisible in a water tank
leaving the sad sack of a straitjacket in the depths
trying to remember his shape,
a coffin or box corking empty to the surface.
Ankles free of "inescapable bonds"
he should have fallen from fifty flights high
towards a fan's open mouth,
a photographer's most extreme close up;
should, in short, have slipped his mortal coil
as deftly as he'd shimmy out of knotted chains.

Randolph's winded by the news all the same,
gasps as Harry must have, takes a long time
to paste *this* clipping in his scrapbook,
a long time to wonder where the great escapers go
when their last trick is their very last;
ponders too, perhaps, on his friend expiring
on the witchiest night of the year: Harry Houdini
ghosting out of his muscles in disbelief.

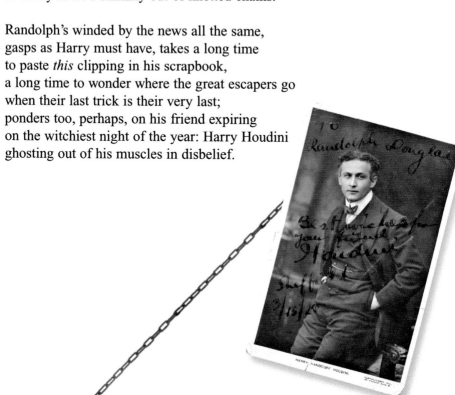

Burying Houdini

You and your split deck life –
half the year's cards in one century,
half in another.

You and the serial unsuccessful suicides
you called 'feats'.

You and your pillow of Mama's letters
beneath your dead, disappearing head.

You and your answer for everything
but life's Great Mystery.

You and your phony birthday,
your perfect death day,
your Hungarian beginnings
bubbling to the surface of the grave.

You and the one casket you didn't spring from,
not hearing the willow wand
broken on its lid,
Bess's water torture tears
dropping like the temperature.

You and your rope-ribboned neck,
your key-minding mouth,
your invisible son, your charity,
your nudity, breath control,
courage and vanity,
your thick black hair, centre split
like that cut deck,
a sawn woman,
the divide between life and death.

How did you ever get into this,
you and your stone-deaf spirit
at their stony-faced séances?
How will you ever get out?

House Of Wonders

Not a seasoned traveller,
he draws the seasons to himself:
a wheel of summer moths and butterflies,
winter lanterns, the spring and fall of other lands.

He leans to the local of Blue John,
the foreign of a Tibetan churn,
the exotic hide shields of Africa,
the polish and spit of a lead miner's boot.

The skull is not anatomically correct
and its use is uncertain
but then what use do we need but to train
a nine volt torch into its softly rocking sockets
and gawp like petrified birds' nests?

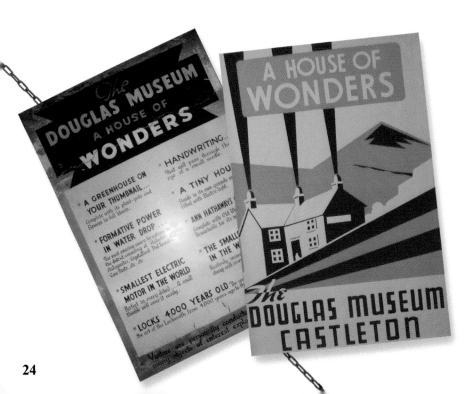

THIS MUSEUM WILL INTEREST YOU !

THE

DOUGLAS MUSEUM

A HOUSE OF
WONDERS
CASTLETON, DERBYSHIRE.

This house is situated at the foot of Peveril Castle, on the way to the Peak Cavern. Here the visitor can see a unique collection from all parts of the world.

CAVERN FORMATIONS.
The Finest Collection in the District.

is to be seen here, consisting of Stalactites, Stalagmites, Curtains, Cave Nests, Pool Formations, etc. RARE MINERAL and GEOLOGICAL SPECIMENS.

LOCKS 4,000 YEARS AGO.

A fine collection of LOCKS and KEYS showing the progress of the locksmith's art, 4,000 YEARS AGO to the present day.

Some Wonders of the World

THE SMALLEST ELECTRIC MOTOR IN THE WORLD.

Perfect in every detail the whole of which will stand under a SMALL THIMBLE.

THE SMALLEST SAFE.

The door of which a penny postage stamp will easily cover.

A GREENHOUSE ON YOUR THUMB NAIL.

A TINY GREENHOUSE, complete with its plant-pots and flowers in full bloom.

HOW SMALL CAN YOU WRITE ?

Handwriting that will pass through the eye of a small needle.

A TINY HOUSE.

Standing in its own grounds and fitted with Electric Light. A beautiful example of miniature architecture.

ANN HATHAWAY'S COTTAGE.

STRATFORD-ON-AVON, with its OLD WORLD GARDENS. A model remarkable for its minuteness of detail.

A WONDER IN CARVING.

A PAIR of TONGS carved from an ORDINARY MATCH, which when closed can fit inside another hollowed out to receive it. The chief point of interest in the TONGS is that they have been carved from ONE SOLID MATCH and not made in TWO PIECES. These along with many CURIOUS objects of general and LOCAL INTEREST will occasion wonder in the most disinterested person.

NO VISITOR SHOULD MISS THIS HOUSE OF WONDERS.

OPEN DAILY - Including Sunday.　　　Proprietor : H. DOUGLAS.

VISITORS ARE PERSONALLY CONDUCTED ROUND AND OBJECTS OF INTEREST EXPLAINED.

Printed by A. Taylor & Sons Ltd., Wombwell, Yorks.

The Bare Bones Of It

Did guests truly lie,
when day was done,
sheet, mattress and springs
away from human bone

then rise, concoct a tale,
a fable spun
about the names and source
of each poor skeleton?

Mischief? Misunderstanding?
I don't know
which put these two lovers,
levelled long ago

by brutal hand and pick
on Winnats Pass,
into this final resting place,
a union at last

on Randolph's floor.
But if not true (and surely not)
and guests pulled two stories' strands
to neatly tie a knot

then it's a knot –
part-truth, part-lie –
that only Randolph (or *Randini*)
could untie.

For legend's sake
let's say it's so:
two lovers,
levelled long ago,

have found a home,
a marriage bed at last
more welcoming than wood,
than earth, than grass.

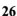

miniatures

he has a head for heights,
an eye for detail
and the fingers of a nimble god,

seals and makes fireproof
a stamp-sized safe,
turns the smallest motor in the world,

conceals a match within a match
within a pencil within a case
within a torch's invasive beam.

now, from a factory smaller than a clock card –
the smell of shredded wheat and the ghost
of pale chimney smoke on the cabinet glass.

bethlehem

mother of jesus
in mother of pearl
wait and make room for us.

we have no star
in this museum's striplight sky
which we can follow.

pray let us find you all
gathered round a sliver of crib
wearing your chain link halos

like so many christening rings,
like so many hoops of confetti
at a wedding of the ways.

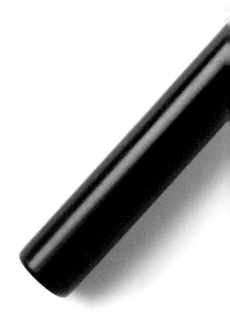

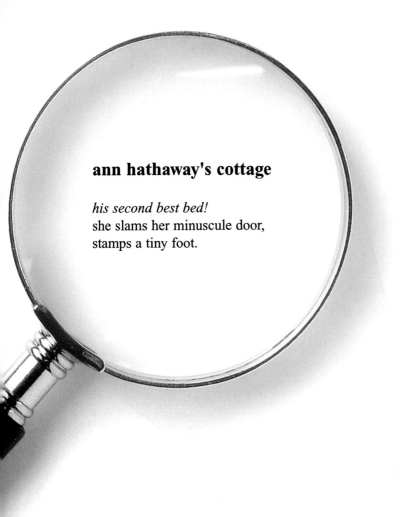

ann hathaway's cottage

his second best bed!
she slams her minuscule door,
stamps a tiny foot.

ann hathaway's cottage

his second best bed!
she slams her minuscule door,
stamps a tiny foot.

greenhouse on your thumbnail

so convenient.
so practical.
so easy to maintain.

we will paint it each spring
with brush hairs fine as ants' eyelashes,
water its forty-two plants within

with the sweat of six midges,
lock them away for safekeeping
with a key the size of a ladybird's toe.

shhh…be still and listen.
you can hear the footsteps of dust mites
heavy as the sound of pins dropping.

greenhouse on your thumbnail

so convenient.
so practical.
so easy to maintain.

we will paint it each spring
with brush hairs fine as ants' eyelashes,
water its forty-two plants within

with the sweat of six midges,
lock them away for safekeeping
with a key the size of a ladybird's toe.

shhh…be still and listen.
you can hear the footsteps of dust mites
heavy as the sound of pins dropping.

the lord's prayer

on the day we finally find that camel
randolph douglas alone will birth the rider
to guide it through the silver eye.

until then, this will suffice:
inked with a mapping pen
without the aid of a glass

this branded paper psalm
looping its humpbacked trail
through a hollow tear

stills to a ribboned horseshoe
of song unstitched but heard
on earth as it is in heaven.

Locks

In contrast to the entropy of all else here
these heavy chambers for spring, pin and rocking plate
stud and rivet this wall with industrial precision.

They are the solid artillery of defence,
protectors of secrets who, with their mushroom mouths
swivelled shut, hold secrets of their own.

To us, both door latch and 'D' gate remain silent and sealed
but to him they are heard and understood,
penetrated to the depths of their mechanised hearts.

He picks his way through a brass and silver trail
of cylinders, shackles and screws,
dampens down the sound of hammer on bell

in the alarm door lock, tiptoes through a metal maze,
sucks the dust from a keyhole with a pipe key
and winds it all up again into solidly lockable life.

Oh, how he must have slid, bolted,
pushed and pulled those levers and lugs,
rolled tumblers, spun wheels and engaged cogs.

Oh, how soundly he must have slept each night
secure in the watch of Yale, Chubb and Cotterill,
nothing rusting but that far edge of sky at day's end

as the sun locked up for the night.

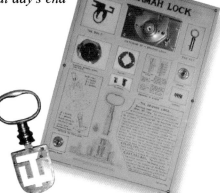

Day Job

Hadfield's Steelworks, Sheffield

"Stone walls do not a prison make, nor iron bars a cage..."
Richard Lovelace (1618 – 1658)

Though swarf clouds choke the steely Sheffield skies
and wind cuts like a hallmarked silver blade
no dream worth dreaming ever truly dies.

A shilling moon, too early, rises high.
Sun fights for space but will not be betrayed
though swarf clouds choke the steely Sheffield skies.

The knots of work aren't easy to untie,
they bind you till the debt of living's paid.
No dream worth dreaming ever truly dies.

Life's cards are dealt. Most play them where they lie
but some free spirits gamble, unafraid,
though swarf clouds choke the steely Sheffield skies

Randolph Douglas is one who's sure to rise
above the nine to five, the grey man's trade.
No dream worth dreaming ever truly dies.

Within his heart he hears the magpie's cries.
One day he'll swap this world for one *he's* made.
Though swarf clouds choke the steely Sheffield skies
no dream worth dreaming ever truly dies.

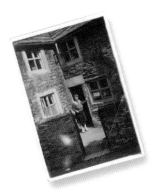

Hetty

And what does Hetty care for those
who dubiously frown and stare
and point out she should wear more clothes
or less transparent underwear?

"At least knit tighter," they decree
but Hetty shrugs as she reveals,
"Randolph likes me to be free"
and he, of all, knows how *that* feels.

Skeleton Key

Bone cold, of course,
chalky to the touch
and imperishable as a spider in death.
You'll hear it one night
tapping on a bass clef hip,
clicking its abacus click
between brittle digits,
unpicking the hidden door
behind the ash grey bookcase.

Better not to think of it,
this one key you'll ever need,
this last latch, this Yale or mortise.
Better the serial number left uncoded,
its maker left unsaid.
You'll have a skin full of this one day after all
and be sick to the jagged back teeth of it –
half-remembering all the doors it opens,
half-forgetting what's on the other side.

Ascension

A hand-held torch is lighting Randolph's way
though whose hand holds it cannot be discerned,
still, surely not a soul on earth could say
his journey through the air has not been earned.
He slips the bonds of sickness, quits the grave,
flies through a theatre window to applause.
He leaves again to circumvent a cave
then enters his museum, there to pause
then soar above the treasures he's amassed –
the eggs, the gourds, the lanterns, shells and locks –
and rises to the clouds until at last
at journey's end he stops and boldly knocks.
He's welcomed in. God's *House of Wonders* waits;
no need to pick the lock of Heaven's gates.

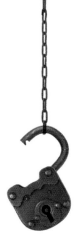

In Search Of Randolph Douglas

Peak Cavern

Only a heart's tongue seems left
to tell of his love for this place,
to describe the tone of his voice,
the width of his stride
and the sound of his boots in Swine Alley.
Only a heart's tongue
and that has told no one for years
but the fern and blue sow thistle.

Every few else unwittingly twists
their individual strands of memory
into a rope of collective amnesia
until the facts unravel *before our very eyes*,
uncoil in this house of meltwaters
and, like that corkscrew wash
between the Styx and Devil's Arse,
spiral out of sight.

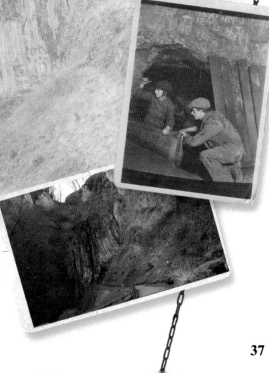

Recollection

Yet nothing dies
no, nothing dies:

the comb remembers the head
the head remembers the skull

the nest remembers the bird
the bird remembers the egg

the whip remembers the skin
the skin remembers the snake

the dark remembers the light
the light remembers the torch

all remember the man
the man who collected 'things'

for a reason forgotten.

Headstone

Wonder what constitutes wonder today?
All of us with our glazed hearts, our glazed eyes,
minds numbed by the familiar. We're streetwise
and cynical, unimpressed, cool, blasé.

In a world such as this he disappears
or turns as tiny in the memory
as those miniatures meticulously
worked on. Childless, his life recedes like hair.

I put down the marker of a poem
to this man who teased my locked eye open;
one who possessed the power to fascinate.
I glimpse his life, his work, visit his home,
sense the bud of wonder slowly ripen.
There's magic in the world. It's not too late.

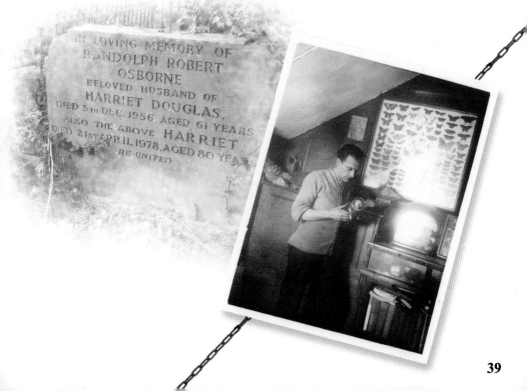

Biographical notes on Randolph Douglas (1895 – 1956)

Randolph Robert Osborne Douglas was born 31st March 1895 in Norton, Derbyshire and grew up in Sheffield. He was an engineer, miniaturist, model maker, escapologist, caver and collector.

An expert on locks and with a keen interest in magic and escapology, Randolph made his first performances as *Randin the Self Liberator* before changing his stage name to *Randini*, almost certainly in homage to Houdini whose career he followed closely. They were to meet and become friends, with Randolph allegedly acting as assistant and/or advisor to Houdini on the latter's subsequent visits to England.

Ill health, as a result of his army service in World War 1, put an end to Randolph's intended stage career. "I did a lot of escapology work in my home," he remarked, "but the war started and, after having done my share, ill health caused me to abandon all thoughts of a strenuous career which demanded good physique like that of Houdini." On his thirty-first birthday he married Harriet (Hetty) Bown in 1926, and moved to Castleton. Both were keen cavers.

Although not a well-travelled man, Randolph had begun collecting curiosities from all over the world. These he acquired either locally or through friends and connections. His collection embraced natural history, geology, art ephemera, locks and his own hand-made miniatures. The latter included tiny replicas of Ann Hathaway's cottage, a Nativity scene, a thumbnail-sized greenhouse ("contains 42 plant pots and flowers in full bloom"), a factory and the Lord's Prayer written on a fine strip of paper and threaded through a needle's eye.

He set up *The Douglas Museum: A House of Wonders*, in his cottage in Castleton at Easter 1926. For an entry fee of sixpence, visitors were shown around by Randolph or Hetty, often by torchlight owing to an absence of electric light. A staying guest later told of two human skeletons stored beneath the bed he had been allocated. Rather fancifully the story was embellished to such a degree that the skeletons' identities were given as the eloping wealthy couple who, in 1758, were robbed and murdered when riding through Winnats Pass.

Randolph worked at Hadfield's Steelworks in Sheffield until 1946, when he became self-employed, running his museum.

Randolph Douglas died on 5th December 1956, after which his beloved wife, Hetty, continued to run the museum until her death in 1978. The collection passed to Derbyshire County Council: Buxton Museum & Art Gallery.

Note: There is a variance in both written accounts and personal reminiscences regarding certain facts and dates pertaining to Randolph Douglas's life. The above information is as accurate as could be ascertained at the time of writing. I believe it to be correct.